ROY STRONG

Nicholas Hilliard

Folio Miniatures

MICHAEL JOSEPH LTD
LONDON

FOLIO MINIATURES

General Editor: John Letts

*First published in Great Britain 1975
by Michael Joseph Ltd
52 Bedford Square London* WC1B 3EF
in association with The Folio Press

ISBN 0 7181 1301 2

PRINTED AND BOUND IN BELGIUM
by Henri Proost & Cie p.v.b.a., Turnhout

1003459729

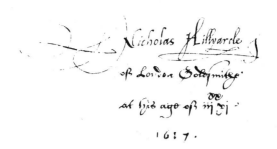

Signature of Nicholas Hilliard, 1617

Nicholas Hilliard was born in Exeter in 1547, the year of the accession of the boy king, Edward VI. His father, Richard Hilliard, was a well-to-do goldsmith, who was later to hold office in the city as both bailiff and sheriff. The Hilliard family included four boys in all: Nicholas, John and Jeremy, who followed in their father's footsteps as goldsmiths, and Ezechiel, who became a clergyman. The family was noted for being zealous in its support of the reformed religion and Richard Hilliard had taken a leading part in the suppression of the rebellion in the south-west in 1549 against the introduction of the First Edwardian Prayer Book. At that time the Protestant community in Exeter was led by a rich merchant, John Bodley, whose son, Thomas, was later to found the Bodleian Library, Oxford. Bodley's militancy was such that under Catholic Mary he was forced to fly to Germany and subsequently contrive the flight of both his wife and children after him. Travelling south this 'family' came to rest in that citadel of Protestantism, Calvin's Geneva. On 8th May 1557 the *Livre des Anglois* records the reception into its congregation, presided over by John Knox, of a family made up as follows: John Bodley, his wife, three sons, one daughter, two servants, one maid, his brother Nicholas and the young Nicholas Hilliard.

In Tudor England it was customary to educate children by placing them in the household of a person of rank and the young Nicholas may well have entered the Bodley household

at the age of nine in 1556. The context in which he appears is redolent of many connexions to come. Nicholas Hilliard's childhood background, therefore, was that of middle class life of a Calvinist cast with its accent on a disciplined round of bible-reading, sermon attendance, psalm singing and daily work as a perpetual expression of prayer and devotion. Geneva in fact left very little impression on his engagingly reckless character, although it did ensure that Hilliard was fluent in the French language, an asset which he was to use to effect twenty years later when he migrated to France.

When the boy returned to England is not exactly known, but it must have been by 13th November 1562 when Hilliard was apprenticed to Robert Brandon, a leading member of the important Goldsmiths' Company and goldsmith and jeweller to the new Queen, Elizabeth I. Under Brandon he served the customary seven years apprenticeship terminating in 1569, when he set up business with his brother John. As a goldsmith he, in turn, took into his own workshop apprentices who studied in the same way that he had under Brandon. Although he was a practising goldsmith, Hilliard was from the very outset of his career a limner or illuminator. Three somewhat feeble miniatures bearing the date 1562, when he was thirteen, reveal a grounding already at that age in the art of painting portrait miniatures. Whether he had learnt this skill in England or in Switzerland is not known but a passage in his own *Art of Limning* reveals that he must from the first have had access to portrait miniatures by Hans Holbein and this suggests an extraordinary talent nurtured in high places from its first manifestation.

His very apprenticeship to the crown jeweller corroborates that he was destined for favour at court. The earliest miniatures, dating from 1572, find their focus in one of Elizabeth I (Pl. 2*a*), confirming that young Hilliard entered directly into royal service. Already in 1573 the Queen had rewarded him with the grant of the reversion of a lease of the rectory and church of Clyve in Somerset for 'his good, true and loyal service'. His success was such that on 15th July 1576 he married his master's daughter, Alice, whose pretty smiling face he captured in one of his most ravishing miniatures (Pl. 3*b*).

A few months after his marriage Hilliard left for France 'with no other intent', reported Sir Amyas Paulet, 'than to increase his knowledge by this voyage, and upon hope to get a piece of money of the lords and ladies here for his better maintenance in England at his return'. This is the first

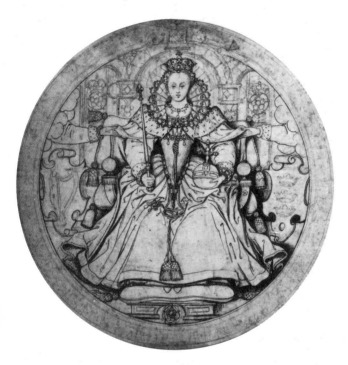

Nicholas Hilliard, Drawing for the Obverse of a
Great Seal of Ireland, circa 1585

reference we have to the financial straits which seem to have made up so much of the remainder of Hilliard's career. He stayed two years in France, partly at the French Embassy, where he painted the young Francis Bacon, and partly in the

service of Elizabeth's suitor, Francis, Duke of Anjou. In France he moved with assurance in the artistic circle which gathered around the brilliant court of the last Valois King, Henry III. Hilliard stayed with Germain Pilon, the sculptor and medallist, and with the Queen Mother Catherine de' Medici's painter, George of Ghent. He conversed with the great humanist poet, Pierre Ronsard, who commented, in tribute, that 'the islands indeed seldom bring forth any cunning man, but when they do it is in high perfection', and, through the humanist philosopher, Blaise de Vignère, received commissions from the Duke and Duchess of Nevers for wood engraved portraits. Nor did he reside solely in Paris but followed the English embassy on its journey south to Poitiers in the summer of 1577.

Sometime between August 1578 and April 1579 Hilliard returned to England. His work in France seems not to have produced the 'piece of money' so much desired for his maintenance in England, so that we find him on return not only borrowing from his father-in-law but dabbling in gold mining in Scotland, a dubious enterprise with dubious people which resulted in his and his colleague's losing 'all their charges', something which the miniaturist still remembered with some bitterness at the close of the second decade of the next century. Presumably prodigal in expenditure, Hilliard must have found it difficult, in spite of no lack of commissions, to support his increasing family. Between 1578 and 1588 Alice gave birth to four sons and three daughters. Names such as Elizabeth (the Queen), Robert (Dudley or Devereux), Francis (Knollys), Lettice (Knollys) and Penelope (Rich) augur sponsors of high rank and highlight Hilliard's connexion with the circle centring on Robert Dudley, Earl of Leicester (Pl. 3a).

For thirty-five years Hilliard carried on his business in the same combination of house and shop in Gutter Lane off Cheapside. But even this ran him into difficulties. His father-in-law finally had so little faith in his handling of money matters that both he and his children went unmentioned in his will in 1591 and provision for a quarterly allowance for his daughter, Alice, was made through the Goldsmiths' Company. For the redemption of a mortgage on his house in 1595 the Queen's last favourite, Robert Devereux, 2nd Earl

of Essex, found the large sum of £140. For the four years following Hilliard had to struggle to get the lease on the house renewed by the Goldsmiths' Company and only after the Privy Council had directly intervened in June 1600 did the Goldsmiths finally agree to renew it for a period of twenty-one years in return for a fine of £30, an annual rent of £3, plus 'a fair picture in great of Her Majesty'. Even with the annual allowance of £40 he had secured by way of Sir Robert Cecil in 1599, he found it hard to gather together the initial £30.

A new reign and a new dynasty did little to impair his position as miniaturist at court, even if fashion now favoured his pupil, Isaac Oliver. By 1613 he had given over the Gutter Lane house to his son and pupil, Laurence, and moved himself to an unknown address in the parish of St Martin-in-the-Fields. Although he failed to get the task of gilding and painting the late Queen's tomb, he was successful in a project he had tried once before to achieve in 1584, namely to secure a monopoly over producing all miniatures and engravings of the King. This was in 1617 but it failed utterly to prevent his imprisonment in his seventieth year in Ludgate as a result of standing surety for another's debt. On 24th December 1618 he made his will and 7th January he was buried in the church of St Martin-in-the-Fields. He gave 20s. to the poor of the parish, household goods to the value of £10 to his servant, Elizabeth Deacon, who had nursed him during his illness, and the residue of his estate to his son, Laurence. It was not the will of a man of substance.

* * * *

We are fortunate that Nicholas Hilliard has left a remarkable description of the Elizabethan court miniaturist at work in the treatise he wrote on the *Art of Limning*. This document remains the most crucial for our understanding of painting in the age of Elizabeth I. Hilliard, who was always very anxious to avoid any possible bracketing of himself with what might be described as 'trade', reiterates several times how miniature painting was 'fittest for gentlemen' as it was 'a thing apart from all other painting or drawing and tendeth

not to common men's use'. Such costly and beautiful creations were designed to adorn the books of princes or, inset into enamelled bejewelled lockets, to deck the sumptuous attire of courtiers. He then embarks on a very precise description of his working methods. To paint miniatures it was necessary always to wear silk clothes, thus avoiding any matter which might shed itself from inferior cloths onto the picture surface. Every care should be taken lest dandruff or spittle fall by accident onto the work in progress. The room in which the miniaturist labours must have a clear easterly light streaming through its windows and the painter's aesthetic impulses might be quickened by fine perfumes, the reading aloud of some good book, discreet conversation or the strains of music. Taking at the very outset 'virgin parchment... as smooth as any satin' he carefully mounts it onto card (frequently a playing card). His sitter takes up a position about two yards away, disposed at a level by which the resulting likeness will evoke immediate recognition in the viewer. This meant that a child would sit lower to be looked down upon or a very tall person higher to be looked up at.

Hilliard achieved his effects by the use of fine brushes or 'pencils'. After the initial underdrawing painting began with the laying in of the flesh tints or 'carnations'. 'When you begin your pictures', writes Hilliard, 'choose your carnations too fair, for in working you may make it as brown as you will, but being chosen too brown you shall never work it fair.' Delineation of form was achieved by 'little light touches with colour very thin, and like hatches as we call it with the pen'. If we examine any Hilliard miniature under a powerful glass (e. g. Pl. 1) it is possible to see the truth of his own description of his technique. The flesh tints are, as he says, applied in delicate washes of colour onto which the features are drawn calligraphically. There is a nervous sensitivity as the lines almost twitch their way across the surface of the miniature, a single line defining an eyebrow, a complex of cross hatching making up the shadows in the flesh tints, or quivering thickly-massed lines following the curls of elaborately crimped hair. Many times enlarged the Elizabethan miniature is strangely akin in its freedom of brushwork to the methods of Impressionist painters of three centuries later. Colour is for the most part primary:

blue and yellow, crimson and black, white and pink, green and orange. Jewels or shot fabrics once glistened with highlights in gold and silver long since blackened with age.

Hilliard's account of his working methods pinpoints closely the sources of his style. In the main, three influences fashioned his art: the first was the inherited linear tradition of his predecessor Hans Holbein the Younger, the second the informality of characterisation developed by Clouet in his drawings of courtiers of the Valois court and, finally, the dictates of Elizabeth I as to what she regarded as being the correct use of light in painting. Through his adherence to Holbein, Hilliard places himself within the context of Northern Renaissance painting with its stress on the definition of form by line as against light and shade. He openly acknowledges his debt to 'the most excellent Albert Dürer' and continues to write that no one who was not able to copy a Dürer engraving so that the copy was indistinguishable from the original should be allowed to limn. In his miniatures Hilliard is transforming the black and white technique of engraving into one using colour. He freely admitted his linear style owed much to Holbein: 'Holbein's manner of limning', he states, 'I have ever imitated, and hold it for the best.' Holbein was taught miniature painting during his second visit to England by a Fleming, Lucas Hornebolte. His style is epitomised in his masterpiece *Mrs Pemberton* in the Victoria & Albert Museum in which the relationship to Hilliard's own style is immediately apparent in the arrangement of the figure and in the sensitive private — as against public — presentation of the sitter. Holbein's late manner and that of the school which followed him, typified by William Scrots and Hans Eworth, accentuated the formalisation of the human figure into an abstract pattern of face, hands, dress and accessories. This tradition too had a pronounced effect on Hilliard, particularly in his formalised votive images of Elizabeth I (e.g. Pl. 7) in which the splendour of her jewels and dress is reduced to a pattern reminiscent of a Byzantine mosaic.

Although Hilliard was resident for two years in France he would from the outset of his working career in 1572 have been familiar with French court portraiture. Portraits both in oil and chalk by François Clouet crossed the Channel in

connexion with the numerous marriage negotiations between the two courts. Its impact was mainly on Hilliard's interpretation of his sitters; he boldly assimilates the spontaneous sparkling gaiety which so often emanates from the crayon drawings of Clouet and his school. Hilliard's portrait of his own wife (Pl. 3*b*) is one of the very best instances of the inspiration that French chalk drawings gave him to break through the public formality of image required by large scale painting and make his miniature art a glimpse into a private world where the frozen mask of rank and office was dropped. To Dürer, Holbein and Hilliard there is the final ingredient: the very pronounced views of Elizabeth I as to the undesirability of shadow. This she expressed forcefully when she first sat for him, an attitude with which Hilliard wisely agreed, as miniatures were 'viewed of necessity in hand near unto the eye', so that the Queen 'chose her place to sit in for that purpose in the open alley of a goodly garden, where no tree was near, nor any shadow at all'.

Hilliard paints with all the passionate conviction of the renaissance artist who truly believed that the face was the mirror of the soul. His enthusiasm was fanned by the belief that the English were favoured with a beauty denied every other race: 'for even the hand, and foot excelleth all pictures I ever saw'. His task was to 'catch these lovely graces, witty smilings, and these stolen glances which suddenly like lightening pass, and another countenance taketh place'. 'Tell not a body when you draw the hands, but when you spy a good grace in their hand', he writes, 'take it quickly.' All these attitudes explain why Hilliard's miniatures have a charmed intimacy denied the formalised abstractions of the large-scale Elizabethan portrait.

Hilliard is known to have painted large-scale portraits but only two can be attributed to him with any degree of certainty: the 'Pelican' and 'Phoenix' portraits of Elizabeth I in the Walker Art Gallery, Liverpool and the National Portrait Gallery. As the miniatures of Hilliard and his pupil, Isaac Oliver, are the crowning glory of painting in the Elizabethan age, they are also governed by the same aesthetics of vision which affected life-scale painting. Although his treatise on limning discusses perspective and its importance, it still remains true to say that the idea that the picture frame was a prosce-

nium arch across which the eye travelled into a space controll-
ed by the laws of linear and aerial perspective was something
entirely foreign to the Elizabethan mind. An Elizabethan or
Jacobean sitter stares out at us from a vacuum silhouetted
against a plain ground which denies its depth by placing
across it at random information defining the sitter, matter
which usually gives age and date, arms and motto. Occasional-
ly the background is a defined box, enclosed by shiny silk
curtains or the canvas of a tent, in which the sitter stands on
an area of rug or rush matting, hand resting on a chair or table.
Rarest of all they are hesitantly placed out of doors in the
world of nature (Pl. 9*b*, 14).

And as in làrge-scale painting the miniatures are
sometimes a compilation of attributes to be read in the
silent language of renaissance allegory. Elizabeth Stanley,
Lady Huntingdon (Pl. 15*b*) clasps her hand to her heart
while, on either side of her, there are mottoes on constancy
in love. A young gallant (Pl. 9*a*) raises his hand meaningfully
to his breast, his hair carefully dishevelled and his dress
delicately ruffled. The Wizard Earl of Northumberland (Pl.
9*b*) lies meditating on the greensward, a book open at his
side, his glove cast behind him. This is a glimpse of the
melancholic philosopher seeking the contemplative solitude
of the greenwood tree, a mood later epitomised in Milton's
Il Penseroso:

> *There in close covert by some brook,*
> *Where no profaner eye my look,*
> *Hide me from day's garish eye,*
> *While the bee with honeyed thigh,*
> *That at her flow'ry work doth sing,*
> *And the waters murmuring*
> *With such consort as they keep,*
> *Entice the dewy feather' sleep;*
> *And let some strange mysterious dream,*
> *Wave at his wings in airy stream...*

The Earl of Cumberland (Pl. 14) appears as Queen's Champion
at the tilt. He it was who led the field each 17th November
in the great tournament held in Elizabeth's honour when
courtiers came as knights of romance to pay their homage
to the Virgin Queen. He wears her glove, elaborately
bejewelled, in his hat; his surcoat lining is embroidered with

emblematic sprigs of olive, armillary spheres and *caducei*. Behind him an abstruse *impresa* or personal device is painted on a little shield hung upon a tree which depicts the world between the sun and moon. These miniatures alone give one an insight into the layers of allusion that can be unravelled from these minute images.

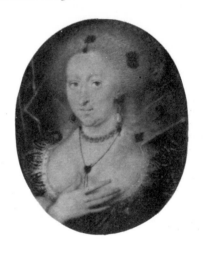

Isaac Oliver, Anne of Denmark wearing a picture box
pinned to her bodice, circa 1611

There is no great development in Hilliard's style. He arrives in full maturity at the age of twenty-five in the miniatures dating from 1572: a striking study of a young man aged 24 (Pl. 2*b*) and a glimpse of Elizabeth I at the age of thirty-nine (Pl. 2*a*). Thereafter follows a dazzling succession of images of the high Elizabethan period culminating in his ambitious exercises in the full length miniature typical of the nineties, *George Clifford, 3rd Earl of Cumberland* (Pl. 14), *Sir Anthony Mildmay* arrogant within his braided pavilion (Pl. 11) and, most poetic of all, the mysterious lovelorn youth among the white roses (Pl. 8). These brilliant characterisations, expressed with immensely free, vigorous brush

work, give way after 1600 to the niggling monotony of his portraits of James I and his family. Even in the Jacobean period, however, the old fire could return. *Lady Elizabeth Stanley* (Pl. 15b) painted circa 1605-10, has all the charm of Hilliard's first observation of the young Elizabeth thirty years earlier and the portrait of the future *Charles I* (Pl. 16) is a *tour de force* for a man in his sixty-eighth year.

Hilliard was truly the founder of the British School of miniature painting. His pupils take the art well into the seventeenth century in a direct line of descent. Only one son, Laurence Hilliard (1582-1640), entered his father's workshop. He continued painting through the reign of Charles I in a decorative if feeble manner based on his father's style, untouched by the revolution of Mytens and Van Dyck. Rowland Lockey (died 1616) entered Hilliard's workshop in 1581 but although two miniatures by him are known he was active chiefly as a copyist of large-scale portraits of which the best known is the group portrait of *Sir Thomas More and his Descendants* in the National Portrait Gallery. Hilliard's teaching may have extended beyond his apprentices to giving drawing lessons to young ladies. A certain Rebecca Pake of Broomfield, Essex, writes in 1595 of her education in the household of an upperclass London lady: 'For my drawing, I take an hour in the afternoon... My lady... telleth me, when she is well, that she will see if Hilliard will come and teach me, if she can by any means, she will'.

By far his most important pupil was Isaac Oliver (1565?-1617) whom Richard Haydocke records as being Hilliard's 'scholar for limning'. Oliver was probably apprenticed to Hilliard in about 1580 and although he owed his master his grounding in the art of miniature technique, his style was formulated by a tradition far different from that of Holbein. Oliver travelled, in particular to the Low Countries in 1588 and to Venice in 1596. From these sources he shaped a style which was to receive fashionable acclaim in the reign in which he was appointed limner to the art-loving Anne of Denmark. It was a style derived from the modelling and dramatic chiaroscuro characteristic of Italian and Netherlandish mannerist painting. With Oliver the miniature reverts to its accustomed role being a reduced version of contemporary life scale painting, a role it has occupied ever since.

The Elizabethan miniature belongs to a lost world of courtly dalliance. These pale, lovely images are badges of loyalty or pledges of true love between sovereign and subject or knight

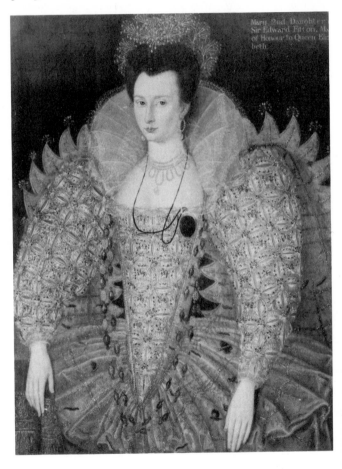

Follower of George Gower, Mary Fitton wearing a picture box
pinned to her bodice, circa 1595

and lady. They were kept concealed in cabinets in bed-rooms or, hidden in lockets, suspended over the hearts of loved ones or boldly flaunted by courtiers at the end of

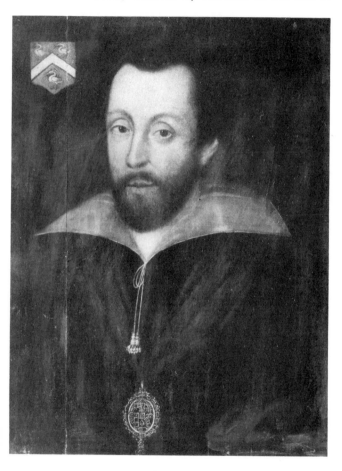

Artist Unknown, Thomas Lyte wearing the Lyte Jewel, circa 1610
(see page 18)

jewelled chains. Staring out at us from unsympathetic eighteenth or nineteenth century frames placed in serried ranks in the vitrine of a country house or the showcase of a museum, it is difficult to recapture their fragile intimacy. We should hesitate before we scrutinize these faces, pause as we would before pressing on through the most intimate moments of a diary or love letter. Lord Herbert of Cherbury's account of Lady Ayres in bed contemplating his own likeness by Hilliard's pupil, Isaac Oliver, captures the mood in its quintessence. 'Coming one day into her chamber', he relates, 'I saw her through the curtains lying upon her bed with a wax candle in one hand, and the picture... in the other'. As Antonio says in *Twelfth Night*:

> ...to his image, which methought did promise
> Most venerable worth, did I devotion.

Elizabethan and Jacobean portraits sometimes show 'picture boxes' as they were called. Anne of Denmark always wore one pinned to the bodice of her dress; it is set with table diamonds in the bold style she promoted and tied by a pretty bow to the neckline (page 12). Mary Fitton in the beautiful portrait at Arbury Hall (page 14) has a plain black picture box at the end of a black cord looped up and attached to her stomacher. Thomas Lyte can be seen wearing the famous Lyte jewel, now in the British Museum, which James I gave to him in 1610 and which contained a Hilliard miniature of the King (page 15). They were also framed in ivory, the cases when closed resembling draughtsmen. Elizabeth I kept her miniatures locked up in her bedroom. Sir James Melville, emissary of Mary Queen of Scots, describes how the young queen opened her cabinet in which he caught a glimpse of her miniature collection, each carefully wrapped in paper and labelled with the sitter's identity: 'Upon the first that she took up was written, *My Lord's picture*', Melville narrates. 'I held the candle, and pressed to see the picture so named. She seemed loath to let me see it; yet my importunity prevailed for a sight thereof, and found it to be the *Earl of Leicester's* picture.'

Late in Elizabeth's reign it became part of the cult of the Virgin Queen to wear her miniature almost as a talisman. Lord Zouche wrote to Sir Robert Cecil in 1598 on receiving a miniature of her — doubtless one of the type in which Hil-

liard rejuvenated her back to a young girl (e.g. Pl. 13) — that he held it to be the fairest picture in Europe: 'I would I could have as rich a box to keep it in as I esteem the favour great.' Three such rich boxes survive, the Armada Jewel (Pl. 7), traditionally given to Sir Thomas Heneage by the Queen on the defeat of the Spanish Armada; a second, also in the Victoria & Albert Museum, of pierced gold and enamel (Pl. 13), and a third, the famous Drake Pendant, still in the possession of descendants. In all three the ageing countenance of Elizabeth I has been transformed into Lord Zouche's vision of the fairest picture in Europe. When Sir Henry Unton showed King Henri IV of France his miniature of the Queen 'he beheld it with passion and admiration', kissing it two or three times while still retained by Unton in his hand. James I was more lavish with his picture but to less effect. When the Earl of Rutland returned from his embassy to Denmark, sixteen of his train were given chains of gold with the king's picture. Others received the picture alone. This mass production of images of the royal family for distribution accounts for the frequently disappointing quality of many of Hilliard's miniatures of James I, Anne of Denmark and their children. Oddly he had never tired of depicting Elizabeth. The numerous idealised likenesses of her during the last decade of her reign offer a succession of brilliant arrangements of hair ornaments, jewels, patterned fabrics and lace.

The payments for these royal portraits are interesting evidence of the price charged by Hilliard for a miniature. In Elizabeth's reign the normal charge was £3. The Earl of Northumberland paid 60s. in 1585-6 and five years later Elizabeth Talbot, Countess of Shrewsbury paid Hilliard the same for 'the drawing of one picture'. Payments for miniatures of James I and family evidence a price rise. In 1608 Hilliard received £15 'for the King's and Prince's pictures given to the Landgrave of Hesse and one other of His Majesty's given to Mr Roper with crystal glasses that covered them'. When Hilliard provided the setting the price could soar. In October 1615 he received £35 'for work done... about a table of his Majesty's picture garnished with diamonds given by his Majesty to John Berkeley'. The Lyte Jewel is such a piece, given by James I to Thomas Lyte on 12th July 1610 (page 18).

Nicholas Hilliard, a man of Devon, is the first English-born painter to have received the unanimous recognition of his contemporaries. Wilful and extravagant by nature, there is

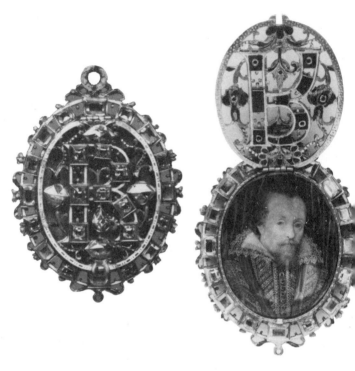

The Lyte Jewel, circa 1610

yet something about his character which marks him as truly Elizabethan and his creations as the pictorial reference above every other for the age in which he lived. It is his naivety, his bold assertiveness, his sudden flashes of genius, his utter freshness of vision and, above all, his unashamed patriotism that makes him one of the most peculiarly English of all our painters. The *literati* rightly admired him. Tribute is paid to

him in sonnets by Sir Arthur Gorges and Henry Constable, Sir John Harrington recounts his wonder at seeing him delineate the Queen's face in four lines, and John Donne has immortalised him in the famous lines in *The Storme* (1597):

> ...a hand, or eye
> *By Hilliard drawn, is worth an history,*
> *By a worse painter made...*

Of all the eulogies paid to him, the one which is most touching in its unexpected remoteness is that by the teacher of Velasquez, Francisco Pacheco (1571-1654) of Seville. Somehow a Hilliard miniature had found its way to Spain and this is what he wrote:

A RARE LIMNING. *This City enjoys possession of a small portrait of an English boy drawn from the life, which the Prebendary Diego Vidal owns today. Framed in ivory, it is an oval on a blue ground, surrounded by letters of gold. The head is done with so much skill, that (in my opinion) it leaves far behind all of this kind I have ever seen. I say truly that methinks Limning could go no farther; and that there the art reached perfection. The Master who did it was an Englishman. But there is no note of his name: a name that for this alone should be ever-living.*

EXTRACTS FROM
HILLIARD'S

TREATISE ON THE ART OF LIMNING

Richard Haydocke in the Preface to his translation of Giovanni Paolo Lomazzo's *Tracte* (1598) refers to the fact that he had asked Hilliard to write his views on miniature painting which he had agreed to carry out as soon as possible. This, together with other internal evidence, in particular the fact that when he was writing Elizabeth I was still alive, establishes that Hilliard compiled it between the years 1597 and 1603. The only surviving manuscript, a copy, is dated 1624, five years after the artist's death.

The following extracts are based, with modernized spelling, on the edition by Philip Norman published by the Walpole Society in 1912. No up-to-date critical edition of the text exists and the following abridgement of the 1912 version makes it available for the first time to the general reader. Besides including a detailed account of his working methods there are fascinating glimpses of the great — Elizabeth I, Sir Philip Sidney, Sir Christopher Hatton and Pierre Ronsard — and general reflections on the aesthetics of painting in the Elizabethan period.

Grateful acknowledgment is made to the Walpole Society for permission to print a transcript based on Nicholas Hilliard's *Treatise on the Art of Limning* by Philip Norman in Vol. 1. (1911-1912)

A TREATISE CONCERNING THE
ART OF LIMNING

...Now therefore I wish it were so that none should meddle with limning but gentlemen alone, for that it is a kind of gentel painting of less subjection than any other; for one may rleave when he will, his colours nor his work taketh any harm by it. Moreover it is secret, a man may use it and scarcely be perceived of his own folk; it is sweet and cleanly to use, and it is a thing apart from all other painting or drawing, and tendeth not to common men's use... being fittest for the decking of princes' books or to put in jewels of gold and for the imitation of the purest flowers and most beautiful creatures in the finest and purest colours which are chargeable, and is for the service of noble persons very meet in small volumes in private manner for them to have the portraits and pictures of themselves...

Here must I needs insert a word or two in honour and praise of the renowned and mighty King Henry VIII, a prince of exquisite judgement and royal bounty, so that of cunning strangers even the best resorted unto him and removed from other courts to his, amongst whom came the most excellent painter and limner Hans Holbein, the greatest master truly in both those arts after the life that ever was... Holbein's manner of limning I have ever imitated and hold it for the best, by reason that of truth all the rare sciences, especially the arts of carving, painting, goldsmiths, embroiderers, together with the most of all the liberal sciences, came first unto us from the strangers, and generally they are the best and most in number. I heard Ronsard, the great French poet, on a time say that the islands indeed seldom bring forth any cunning man, but when they do it is in high perfection, so then I hope there may come out of this our land such a one, this being the greatest and most famous island of Europe.

The most excellent Albert Dürer was born in Germany, a part of the greatest mainland in Europe, which breedeth or might breed more than a hundred workmen for us one, this Albert being as exquisite and perfect a painter and master in the art of graving on copper as ever was since the world

began (that by many works extant appeareth), and which also hath written the best and most rules of and for painting and graving hither unto of any master until Paolo Lomazzo… doubtless he (Dürer) was the most exquisite man that ever left us lines to view for true delineation… but yet… by reason he was no great traveller, that he never saw those fair creatures that the Italians had seen… surpassing all other portraitures of the Dutch whatsoever, yea even nature itself, except in very few, which rare beauties are… more commonly found in this isle of England than elsewhere, such surely as art must give place unto. I say not for the face only, but every part, for even the hand and foot excelleth all pictures that yet I ever saw. This moved a certain pope to say England was rightly called Anglia, of Angely, as the country of Angels, God grant it.

…the first and chiefest precepts which I give is cleanliness, and therefore fittest for gentlemen, that the practiser of limning be precisely pure and cleanly in all his doings, as in grinding his colours in [a] place where there is neither dust nor smoke, the water well chosen or distilled most pure… at the least let your apparel be silk, such sheddeth least dust or hairs, wear nothing straight, beware you touch not your work with your fingers, or any hard thing, but with a clean pencil brush it, or with a white feather, neither breathe on it, especially in cold weather, take heed the dandruff of the head shedding from the hair, and of speaking over your work for sparkling, for the least sparkling of spittle will never be holpen if it light in the face or any part of the naked.

The second rule is much like the first, and concerning the light and place where you work in. Let your light be northward somewhat toward the east, which commonly is without sun shining in; one only light, great and fair let it be, and without impeachment or reflection of walls or trees, a free skylight… in a place where neither dust, smoke, noise nor stench may offend. A good painter hath tender senses, quiet and apt… Discreet talk or reading, quiet mirth or music offendeth not, but shorteneth the time and quickeneth the spirit, both in the drawer and he which is drawn; also in any wise avoid anger, shut out questioners or busy fingers…

Now know that all painting imitateth nature or the life in everything, it resembleth so far forth as the painter's memory or skill can serve him to express... of all things the perfection is to imitate the face of mankind... In the comeliness and beauty of the face... it consisteth in three points: the first and least is the fair and beautiful colour or complexion, which even afar off as near is pleasing greatly all beholders; the next and greater part is the good proportion sometime called favour, where of our divine part... knoweth by nature, without rule or reason for it, who is well proportioned or well favoured, etc.; but the third and greatest of all is the grace in countenance, by which the affections appear, which can neither be well used nor well-judged of but of the wiser sort, and this principal part of the beauty a good painter hath skill of and should diligently note... How then the curious drawer watch, and as it [were] catch these lovely graces, witty smilings, and these stolen glances which suddenly like lightening pass and another countenance taketh place, except he behold, and very well note and conceit to like?

... So chiefly the drawer should observe the eyes in his pictures, making them so like one to another as nature doth, giving life to his work... for all the features in the face of a picture the eye showeth most life, the nose the most favour, and the mouth the most likeness, although likeness is contained in every part, even in every feature, and in the cheeks, chin and forehead, with the compass of the face, but yet chiefly in the mouth... Albert Dürer giveth this rule, that commonly all faces hold one measure and true proportion... that the forehead is of the length of the nose, and the nose as long as from the nose to the chin; if it differ in this it is deformity (by this rule). How be it I have known to hold in right good favours in some few... therefore I will be bold to remember me of one, namely Sir Christopher Hatton, sometimes Lord Chancellor of England, a man generally known and respected of all men amongst the best favours, and to be one of the goodliest personages of England, yet had he a very low forehead, now answerable to that good proportion of a third part of his face... I would willingly give many observations touching proportion fit to be known... yet one word more in remembrance of an excellent man, namely Sir Philip Sidney,

that noble and most valiant knight, that great scholar and excellent poet, great lover of all virtue and cunning: he once demanded of me the question, whether it were possible in one scantling, as in the length of six inches of a little or short man, and also of a mighty big and tall man in the same scantling, and that one might well and apparently see which was the tall man, and which the little, the picture being just of one length. I showed him that it was easily discerned if it were cunningly drawn with true observations, for our eye is cunning, and is learned without rule by long use, as little lads speak their vulgar tongue without grammar rules...

Forget not therefore that the principal part of painting or drawing after the life consisteth in the truth of the line... This makes me to remember the words also and reasoning of Her Majesty when first I came in Her Highness' presence to draw, who after showing me how she noted great difference of shadowing in the works and diversity of drawers of sundry nations, and that the Italians, [who] had the name to be cunningest and to draw best, shadowed not, requiring of me the reason of it, seeing that best to show oneself needeth no shadow of place but rather the open light; to which I granted, [and] affirmed that shadows in pictures ... give unto them a grosser line ... Here Her Majesty conceived the reason, and therefore chose her place to sit in for that purpose in the open alley of a goodly garden, where no tree was near, nor any shadow at all, save that as the heaven is lighter than the earth so must that little shadow that was from the earth ...

Now a word or two of colours, for which are fit for limning, and which are not. All ill smelling colours, all ill tasting ... or any unsweet colours are naught for limning, use none of them if you may chose ... Some authors sayeth there are but two colours, which are black and white, because indeed in white and black all things are or may be in a manner very well described ... Now besides whites and blacks, there are but five other principal colours which are colours of perfection in themselves ... murrey, red, blue, green and yellow.

Know also that parchment is the only good and best thing to limn on, but it must be virgin parchment, such as never

bore hair ... It must be most finely dressed, as smooth as any satin, and pasted with starch, well strained on pasteboard, well burnished, that it may be pure without specks or stains, very smooth and white.

Then must you lay your carnation flowing and not thin driven as an oil colour; and when you begin your picture chose your carnations too fair, for in working you may make it as brown as you will, but being chosen too brown you shall never work it fair enough, for limning is but a shadowing of the same colour your ground is of...

When your colours are dry in the shell you are to temper them with your ring finger very clean when you will use thereof, adding a little gum if it temper not well and flowingly, but beware of too much; if any colour crack too much in the shell, temper there with a little sugar candy, but a very little, least it make it shine... If a colour will not take by reason that some sweaty hand or fatty finger hath touched your parchment thereabout, temper with that colour a very little earwax ... Liquid gold and silver must not be tempered with the finger but only with the pencil, and with as little gum as will bind it that it wipe not off with every touch, and with a pretty little tooth of some ferret or stoat or other wild little beast.

You may burnish your gold and silver here or there as need requireth, as your silver when you make your diamonds first burnished then drawn upon with black in squares like the diamond cut. Other stones must be glazed upon the silver with their proper colours with some varnish ... Shadowing in limning must not be driven with the flat of the pencil as in oil work, distemper, or washing, but with the point of the pencil by little light touches with colour very thin. and like hatches as we call it with the pen ... Wherefore hatching with the pen, in imitation of some fine well graven portraiture of Albert Dürer['s] small pieces, is first to be practised and used before one can begin to limn, and not to learn to limn at all till one can imitate the print so well as one shall not know the one from the other, that he may be able to handle the pencil

point in like sort. This is the true order and principal secret in limning, which that it may be the better remembered, I end with it.

In drawing after the life sit not nearer than two yards from the party, and sit as even of height as possibly you may, but if he be a very high person, let him sit a little above, because generally men be under him, and will so judge of the picture, because they under view him; if it be a very low person or child, use the like discretion in placing him somewhat lower than yourself. If you draw from head to foot, let the party stand at least six yards from you, when you take the discription of his whole stature, and so likewise for the stealing of your picture, what length soever, after you have proportioned the face, let the party arise, and stand, for in stitting few can sit very upright as they stand, whereby the drawer is greatly deceived commonly, and the party drawn disgraced. Tell not a body when you draw the hands, but when you spy a good grace in their hand take it quickly, or pray them to stand but still, for commonly when they are told, they give the hand the worse and more unnatural or affected grace...

FURTHER READING

The most important survey of Nicholas Hilliard's life and work is Erna Auerbach's *Nicholas Hilliard*, London, 1961. This includes a bibliography of all literature on Hilliard until that date. Of the items listed the following are the most valuable:

John Pope-Hennessy, 'Nicholas Hilliard and Mannerist Art Theory', *Journal of the Warburg and Courtauld Institutes*, VI, 1943, pp. 89-100

Graham Reynolds, *Nicholas Hilliard and Isaac Oliver*, Catalogue of an exhibition, Victoria & Albert Museum, 1947. Reissued, 1971

Carl Winter, *Elizabethan Miniatures*, King Penguin Book, 1943

Since 1961 the following of interest have also appeared:

Leslie Hotson, 'Queen Elizabeth's Master Painter', *Sunday Times Magazine*, 22nd March 1970, pp. 46-53

Graham Reynolds, 'The Painter plays Spider', *Apollo*, LXXIX, 1964, pp. 279-84

Roy Strong, *Portraits of Queen Elizabeth I*, Oxford, 1963

Roy Strong, *The English Icon. Elizabethan and Jacobean Portraiture*, London, 1967.

THE PLATES

1. SELF-PORTRAIT, 1577 (enlarged). *Victoria & Albert Museum (Salting Bequest)*, No. *P.155-1910*. Diameter, $1\frac{5}{8}$ inches.

 The miniature depicts Hilliard at the age of thirty and was painted while he was in France. It is almost certainly identical to one mentioned in his son's will in 1640.

2a. ELIZABETH I, 1572. *National Portrait Gallery*, No. *108*. Oval, $2 \times 1\frac{7}{8}$ inches.

 The earliest dated portrait miniature of Elizabeth and presumably the result of the sitting Hilliard describes in his *Treatise* (p. 24).

2b. UNKNOWN MAN, 1572. *Victoria & Albert Museum*, No. *P.1-1942*. Rectangular, $2\frac{3}{8} \times 1\frac{7}{8}$ inches.

 The miniature depicts a man aged twenty-four in 1572. A pendant of the wife, aged eighteen, is in the Buccleuch Collection.

3a. ROBERT DUDLEY, EARL OF LEICESTER, 1576. *National Portrait Gallery*, No. *4197*. Diameter, $1\frac{3}{4}$ inches.

 Painted the year before Hilliard's visit to France. Hilliard was closely connected with many members of the circle which found its focus on Elizabeth's favourite. In 1572 he prepared a 'book of portraitures' for him and in 1582 Leicester interceded for Hilliard at court. A full length miniature by Hilliard remained a family heirloom in 1640.

3b. ALICE BRANDON, MRS. HILLIARD, 1578. *Victoria & Albert Museum*, No. *P.2-1942*. Diameter, $2\frac{3}{8}$ inches.

 Painted by Hilliard while he was in France, it was later enlarged with an inscription referring to the sitter as the artist's first wife which implies a second marriage. On the left are the Hilliard arms with those of the Brandon family to the right. This miniature is a striking instance of the influence of Clouet on Hilliard's presentation of his sitters.

4. MARY, QUEEN OF SCOTS, circa 1578 (enlarged). *Private Collection*. Oval, $2 \times 1\frac{5}{8}$ inches.

Hilliard was apparently granted access to Mary, Queen of Scots during her long imprisonment. The direct observation of the Queen's features embodied in this miniature argues for a sitting from life. This likeness was the basis from which the numerous large scale portraits of Mary were worked up during the reign of her son, James I, and later. The miniature was formerly part of a group once in the Stuart royal collection. Many of the large portraits based on it bear the date 1578 which would suggest the date of the miniature.

5*a* and *b*. JOHN AND FRANCES CROKER, circa 1580-5. *Victoria & Albert Museum (Salting Bequest), No. P.139-1910. a.* Oval, $1\frac{7}{8} \times 1\frac{1}{2}$ inches. *b.* Oval, $2 \times 1\frac{5}{8}$ inches.

Double portrait of John Croker, son of Sir Gerard Croker, and his wife Frances, daughter of Sir William Kingsmill. Both these miniatures can be strikingly paralleled in the large scale portraiture of the period, especially those painted by George Gower, Serjeant Painter to the Queen, with whom Hilliard was very closely associated in 1584 in attempting to obtain a monopoly over a production of royal portraits.

6*a*. UNKNOWN LADY, circa 1590. *Victoria & Albert Museum, No. P.8-1945. R. A. Stevenson Bequest*. Oval, $2 \times 1\frac{3}{4}$ inches.

A striking example of Hilliard's work at its apogee.

6*b*. UNKNOWN MAN CLASPING A HAND ISSUING FROM A CLOUD, 1588. *Victoria & Albert Museum, No. P.21-1942.*

Two identical versions of this miniature are extant. It is a particularly potent instance of the alliance of allegory and countenance typical of Elizabethan portraiture. The hand issuing from the cloud usually betokens celestial aid and the composition is reminiscent of Hans Eworth's Allegory of *Sir John Luttrell* (Courtauld Institute). The motto translated is *And therefore of Attic love.*

7. THE ARMADA JEWEL, circa 1588. *Victoria & Albert Museum, No. M81-1935.* Oval, 2¾ × 2 inches.

An elaborate jewel, probably designed if not executed by Hilliard himself. The jewel is of enamelled gold set with diamonds and rubies and suitably unfolding layers of compliment to the queen. On the front of the lid the Ark floats on the waters with the motto: *Calm through savage seas;* inside the lid, a rose is encircled by another motto: *Alas that virtue endued with so much beauty should not uninjured enjoy perpetual life.* The miniature within, which is damaged, depicts the Queen in idealised form. By tradition this jewel was given to Sir Thomas Heneage by the Queen on the defeat of the Spanish Armada.

8. UNKNOWN YOUNG MAN AMONG ROSES, circa 1590. *Victoria & Albert Museum (Salting Bequest), No. 163-1910.* Oval, 5⅜ × 2¾ inches.

The most celebrated of all Hilliard's miniatures. The sitter is unknown although it has been suggested that it could be the young Robert Devereux, 2nd Earl of Essex. As a whole the composition is symbolic of unrequited love, the young man clasps his heart, and stands entwined by eglantine roses, symbolic of chastity, while a motto, which can be variously translated, alludes to the suffering caused by loyalty.

9a. UNKNOWN YOUTH, circa 1595. *Victoria & Albert Museum No. P3-1974.* Oval, 2 × 1⅝ inches.

One of five miniatures each with their original ivory cases traditionally said to have been given to Penelope, Lady Rich by the Queen.

9b. HENRY PERCY, 9TH EARL OF NORTHUMBERLAND, circa 1595. *The Fitzwilliam Museum, Cambridge, No. P.E. 3-1953.* Oval 2 × 2⅜ inches.

A large version of this miniature depicts the Earl reclining within a garden with clipped yew hedges. In the eighteenth century Vertue records it as 'a Lord Percy, a limning lying on the ground'. See above p. 11.

10. JEWELLED LOCKET WITH PORTRAITS OF AN UNKNOWN MAN AND WOMAN, circa 1590. *Private Collection in England*. Man, oval, $1 \times \frac{3}{4}$ inches. Woman, oval, $\frac{9}{10} \times \frac{3}{4}$ inches.

The jewel, which is close in feeling to the Armada Jewel, is of enamelled gold set with rubies and emeralds.

11. SIR ANTHONY MILDMAY, circa 1595. *Cleveland Museum of Art*: Purchased from the J. H. Wade fund. Rectangular, $9\frac{1}{4} \times 6\frac{7}{8}$ inches.

12. SIR HENRY SLINGSBY, 1595. *The Fitzwilliam Museum, Cunliffe Bequest, 1937*. Oval, $3\frac{3}{8} \times 2\frac{1}{2}$ inches.

A striking instance of Hilliard's style in the last decade of Elizabeth's reign. The scale is larger than usual.

13. JEWELLED LOCKET WITH A PORTRAIT OF QUEEN ELIZABETH I, circa 1590–1600. *Victoria & Albert Museum, No. 4404-1857*. Oval, $2\frac{1}{2} \times 1\frac{7}{8}$ inches.

The lid is of pierced gold and the back of the locket is enamelled in a design of dolphins and foliage on a black ground. This is perhaps Hilliard's most poetic interpretation of the ageing queen, reflecting the homage paid her during her last years as an unchanging and unfading beauty, the lovely sonnet mistress of successive generations of courtiers.

14. GEORGE CLIFFORD, 3RD EARL OF CUMBERLAND, circa 1590. *National Maritime Museum, Greenwich*. Rectangular, $10\frac{1}{8} \times 7$ inches.

The miniature depicts Clifford in the role he assumed at the Accession Day Tournament on 17th November 1590 of Queen's Champion at the Tilt. In this capacity he led the field each year in the role of the Knight of Pendragon Castle. He wears fancy dress: Greenwich School armour studded with stars, a surcoat, the lining of which bears symbolic olive branches, *caducei* and armillary spheres. In his hat he sports the Queen's glove and on the tree behind him hangs a pasteboard shield of a type presented to Elizabeth by the Knights at her

Accession Day Tilts bearing an obscure *impresa* with the earth between the sun and moon and the Spanish motto: *Hasta quan.*

15a. JAMES I, circa 1605. *Victoria & Albert Museum, No. P.3-1937.* Oval, $2\frac{1}{8} \times 1\frac{5}{8}$ inches.

A good instance of a typical miniature by Hilliard of the king shortly after he changed his style to King of Great Britain, the title inscribed around the edge of the background.

15b. ELIZABETH STANLEY, COUNTESS OF HUNTINGDON, circa 1605-10. *Private collection in England.* Oval, $2\frac{1}{2} \times 2$ inches.

One of the most beautiful of Hilliard's late miniatures depicting the young Countess with hand on heart, surrounded by emblematics on the nature of her love.

16. CHARLES I AS PRINCE OF WALES, 1614. *The Duke of Rutland, Belvoir Castle.* Oval, $3\frac{1}{4} \times 2\frac{3}{4}$ inches.

One of the most splendid of Hilliard's late miniatures depicting the future Charles I at the age of fourteen. Although it gives him the title of Prince of Wales and the feathers device, Charles was not officially created Prince until 1616.

Grateful acknowledgment is made to the following for permission to reproduce black and white photographs:—Victoria and Albert Museum, *pages* 3 and 12; British Museum, *pages* 5 and 18; Commander the Hon. F.H.M. Fitzroy Newdegate and The Royal Academy of Arts, *page* 14; Somerset County Museum, Taunton, *page* 15.

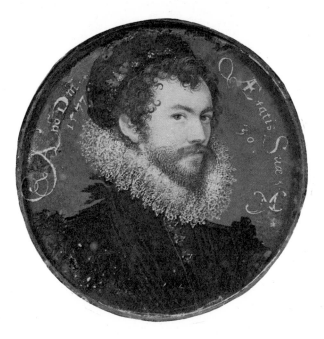

1. Self-portrait, 1577 (enlarged)

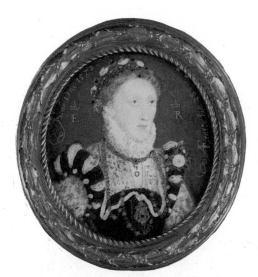

2a. Elizabeth I, 1572

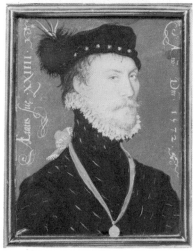

2b. Unknown man, 1572

34

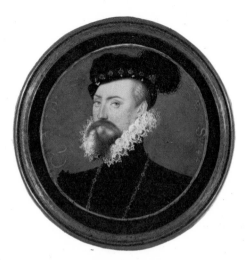

3a. Robert Dudley, Earl of Leicester, 1576

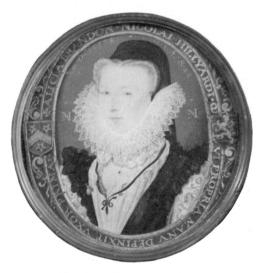

3b. Alice Brandon, Mrs Hilliard, 1578

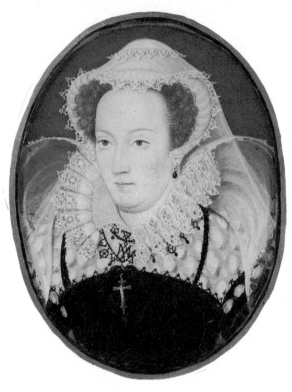

4. Mary, Queen of Scots, circa 1578 (enlarged)

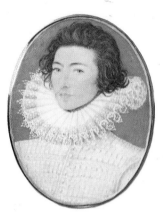

5*a*. John Croker, circa 1580-5

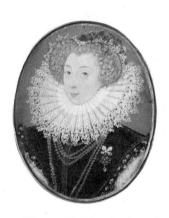

5*b*. Frances Kingsmill, Mrs Croker, circa 1580-5

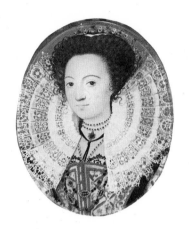

6a. Unknown lady, circa 1590

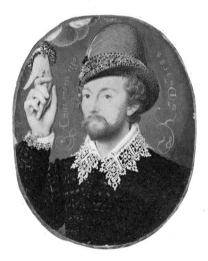

6b. Unknown man clasping a hand from a cloud, 1588

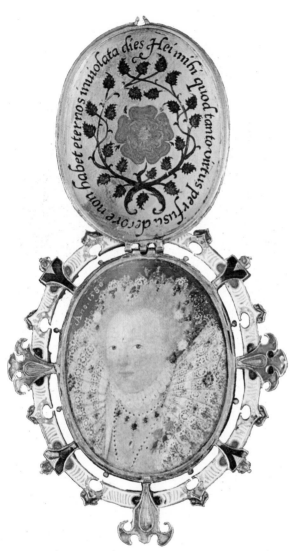

7. The Armada Jewel, circa 1588

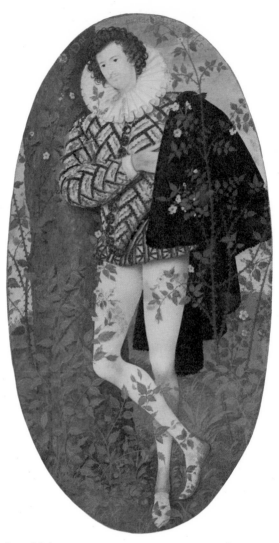

8. Unknown young man among roses, circa 1590

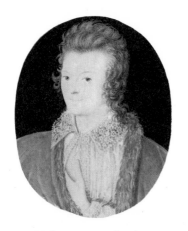

9a. Unknown youth, circa 1595

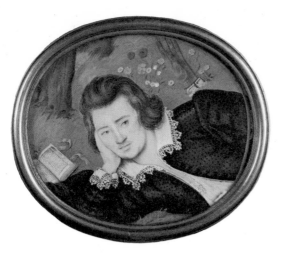

9b. Henry Percy, 9th Earl of Northumberland, circa 1595

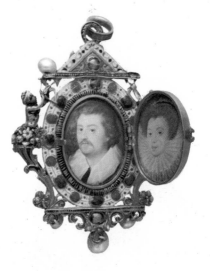

10. Jewelled locket with portraits of an unknown man and woman, circa 1590

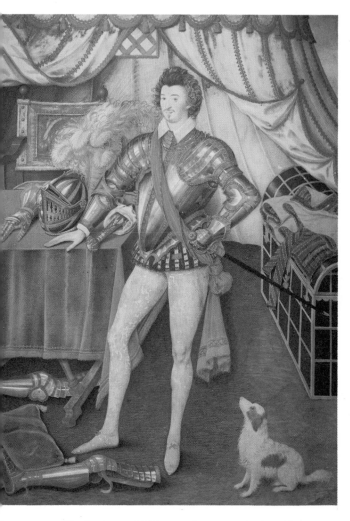

11. Sir Anthony Mildmay, circa 1595 (reduced)

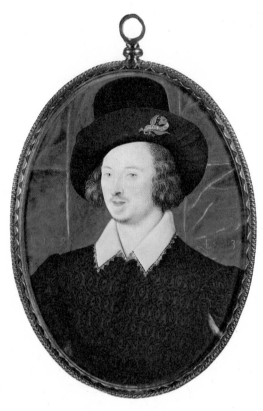

12. Sir Henry Slingsby, 1595

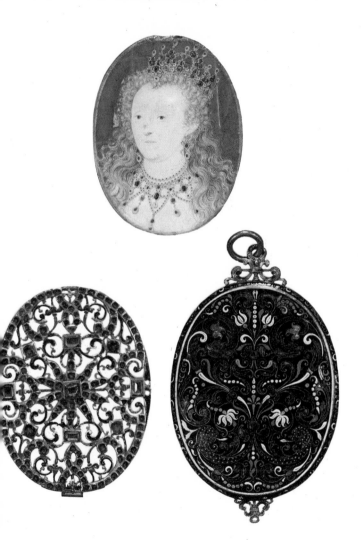

13. Jewelled locket with a portrait of Elizabeth I,
circa 1590–1600

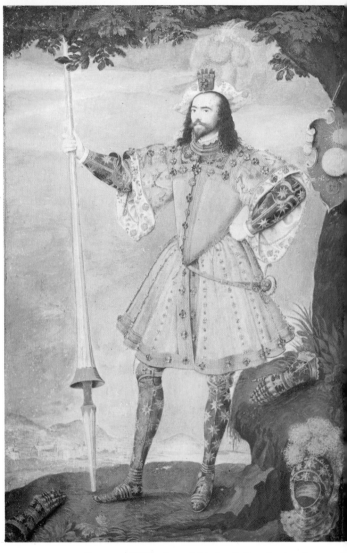

14. George Clifford, 3rd Earl of Cumberland,
circa 1590- (reduced)

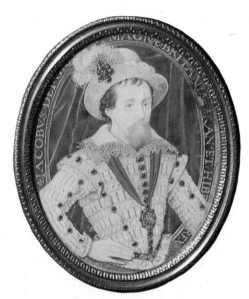

15a. James I, circa 1605

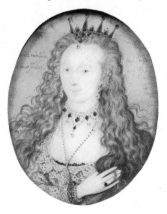

15b. Elizabeth Stanley, Countess of Huntingdon,
circa 1605-10

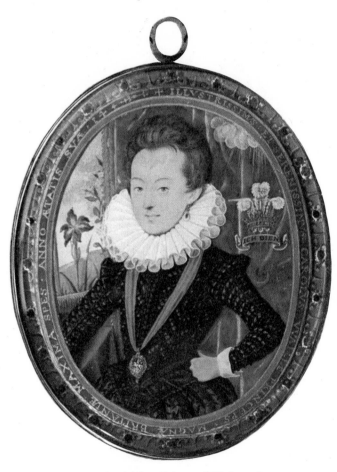

16. Charles I as Prince of Wales, 1614